Christopher Hart's DRAW MANGA NOW!

Best Friends Forever

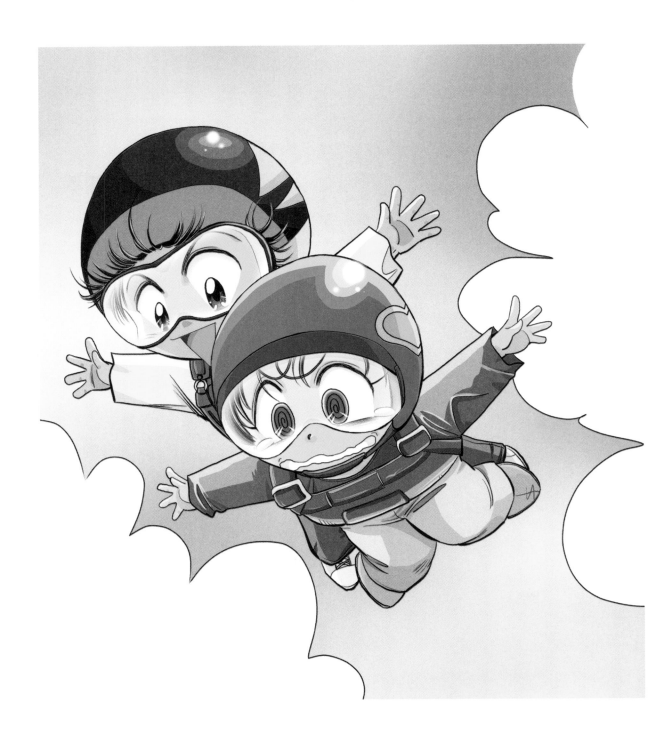

Best Friends Forever

Christopher Hart

Watson-Guptill Publications
New York

Published in the United States by Watson-Guptill Publications, an imprint of the Crown Publishing Group, a division of Random House, Inc., New York.

www.crownpublishing.com
www.watsonguptill.com

WATSON-GUPTILL is a registered trademark and the WG and Horse designs are trademarks of Random House, Inc.

This work is based on the following titles by Christopher Hart published by Watson-Guptill Publications, an imprint of the Crown Publishing Group, a division of Random House, Inc.: *Manga Mania Shoujo*, copyright © 2004 by Christopher Hart; *Manga Mania Chibi and Furry Characters*, copyright © 2006 by Christopher Hart; *Manga Mania Magical Girls and Friends*, copyright © 2006 by Christopher Hart; *Manga for the Beginner Chibis*, copyright © 2010 by Star Fire LLC; *Manga for the Beginner Shoujo*, copyright © 2010 by Cartoon Craft LLC; and *Manga for the Beginner Kawaii*, copyright © 2012 by Cartoon Craft LLC.

Library of Congress Cataloging-in-Publication Data

Hart, Christopher, 1957-
 Best friends forever: Christopher Hart's draw manga now! / Christopher Hart.-1st ed.
p. cm
1. Human beings—Caricatures and cartoons. 2. Comic books, strips, etc.—Japan—Technique. 3. Cartooning—Technique. 4. Friendship in art. 5. ART / Techniques / Drawing. 6. ART / Study & Teaching. 7. ART / Techniques / General.
NC1764.8.H84 H365 2013
741.5/1
 2013002120

ISBN 978-0-385-34547-7
eISBN 978-0-385-34534-7

Cover and book design by Ken Crossland
Printed in the United States of America

10 9 8 7 6 5 4 3 2
First Edition

Contents

Introduction

Everyone has to have a pal, a true-blue friend who can keep a secret, chat endlessly on the phone, and never let you down. When it seems like the whole world is against you, you've got to have a best friend you can talk to. This is an essential tool in visual storytelling. Without the best friend, how would the star of the story express her thoughts?

The best friend character is typically perky and cute, but all types of characters can pair off together—even troublemakers! The key to creating best friends is to show two characters sharing the same moment together. It almost doesn't matter if each one has the same expression; they are reacting to things simultaneously, which shows friendship, visually.

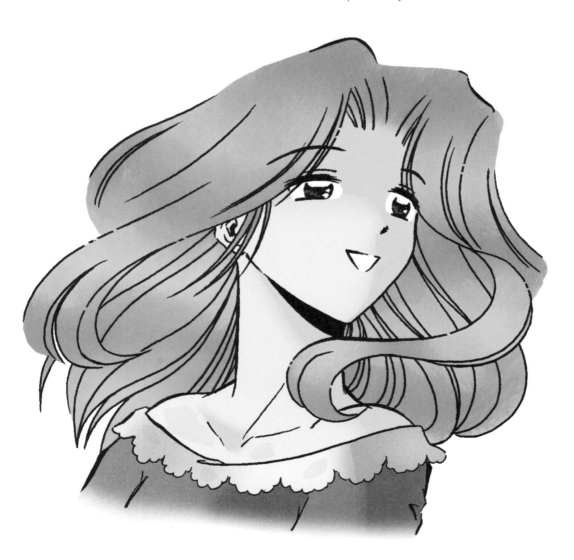

To the Reader

This book may look small, but it's jam-packed with information, artwork, and instruction to help you learn how to draw manga like a master!

Friendships (and rivalries) are central to almost every manga story and genre. We'll start off by going over the basics you need in order to draw manga friends together. Pay close attention; the material we cover here is very important. You might want to practice drawing some of the things in this section, like important poses, expressions, and character types.

Next, it'll be time to pick up your pencil and get drawing! Follow along my step-by-step drawings on a separate piece of paper. When you draw the characters in this section, you'll be using everything you learned so far.

Finally, I'll put you to the test! The last section of this book features drawings that are missing some key features. It's your job to finish these drawings, giving characters the clothes, expressions, and friends they need.

This book is all about learning, practicing, and, most importantly, having fun. Don't be afraid to make mistakes, because let's face it: every artist does at some point. Also, the examples and step-by-steps in this book are meant to be guides. Feel free to elaborate and embellish them as you wish. Before you know it, you'll be a manga artist in your own right!

Let's begin!

PART ONE
Let's Learn It

Face Angles

If your character only appears in the front view, it gets a little boring. One of the main reasons to change head angles is to add variety to a story.

3/4 View

The 3/4 view is a flattering angle, and one that's often used for portraying characters in scenes together. It's a bit more challenging to draw because the two sides of the face aren't mirror images of each other, as they are in the front view.

On the far side of the face, the forehead gently curves in, and the cheek gently protrudes out. The far eye is always smaller than the near eye, due to perspective. And the tip of the nose no longer appears in the middle of the face but is placed closer to the protruding cheek.

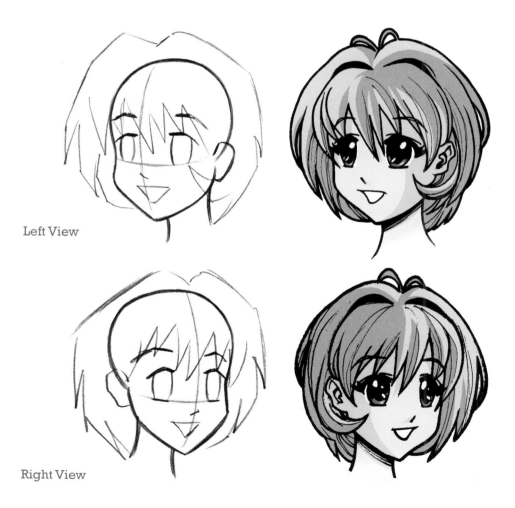

Left View

Right View

Side View

You'll also use this view when drawing characters together. When drawing profiles, start with a big circle. Delineate the bridge of the nose. Note that the ear does not attach to the back of the head but appears *inside* the outline of the head.

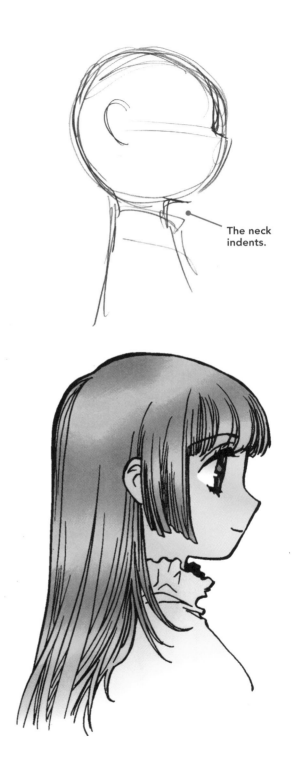

The neck indents.

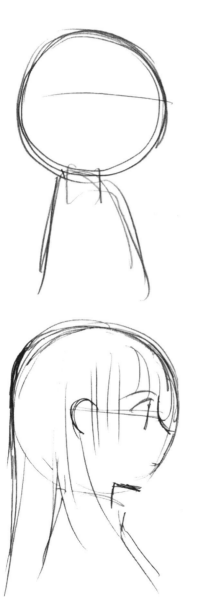

Interactive Poses

Drawing characters standing stiffly keeps them from looking lively and outgoing. But, by changing just one or two parts of a stiff pose, the character will instantly look more alive, and you'll be able to draw characters engaged in conversation, and reacting to each other. For example, just by placing a hand on a hip, a character's pose becomes more interesting, and hints that she is paying attention to someone else.

3/4 View

Placing one hand on the hip adds variety to an otherwise symmetrical pose. This standing pose is the one you'll probably use the most frequently when drawing characters interacting with each other.

For the 3/4 view, always indicate the center line, not only down the face but down the torso, as well. Everything that appears on the far side of the center line—like shoulders, arms, and legs—should be drawn slightly smaller than the same elements that appear on the near side of the center line.

Side View

The side view is all about posture. You might see this one as characters engage in conversations with each other, but this is more of a serious-looking character. The upper body curves back, while the lower body stands straight, and it looks like she's listening intently.

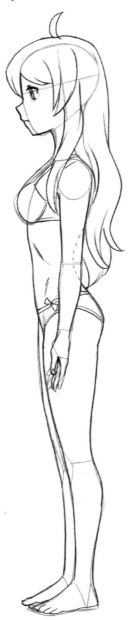

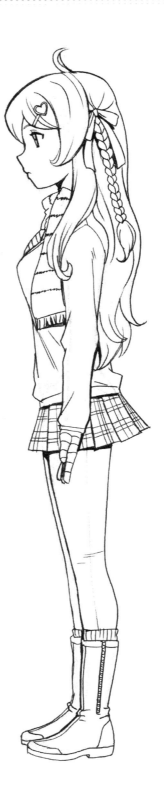

More Interactive Poses

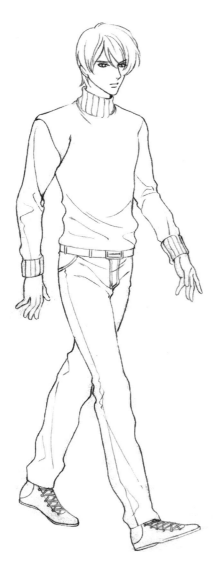

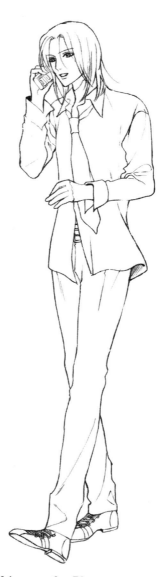

Walking

The arms move in front and behind the torso, and one leg crosses behind the other. This is a basic pose for a character walking with someone or on their way to see a friend.

Talking on the Phone

Something as basic as talking on a cell phone animates a character significantly. We can imagine that he's on his way to meet whomever he is speaking to on the phone (his girlfriend, perhaps). The walk takes on more urgency because he's speaking in an engaged manner. We want to know what's being said, and this draws us into the scene.

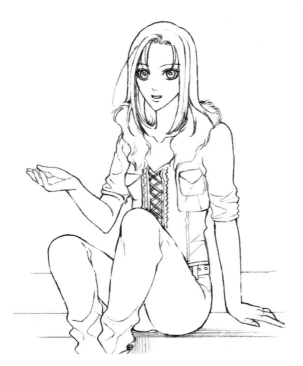

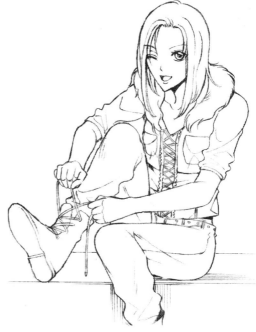

Sitting and Talking

This is a good, simple pose. She gestures nicely with her hand, and you can tell she's speaking because her mouth is slightly open.

Tying Shoes

What does it mean that she's tying her shoe? It means that she's getting ready to go meet up with a friend! And that wink at the reader also helps, adding a touch of flirty humor. Other similar actions could be zipping up a vest, putting on her boots (easier to draw than tying laces), tying a hood into place, or putting on mittens.

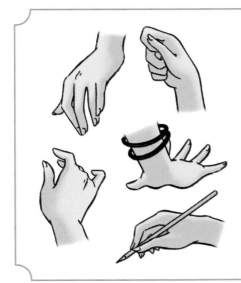

Basic Hand Pointers (No Pun Intended)

You'll want to draw a character's hands doing something, as they interact with others. Remember:

- The palm is based on a rectangular shape.
- The fingers are uneven in length.
- You don't have to draw nails if you taper the fingers to a gentle point.
- Try to vary the finger placement.

Talking
Standing and talking is the most common pose in manga graphic novels. But it can become boring having characters just stand there next to speech balloons with their mouths open. A hand gesture, like this one, helps a little, but the energy level is still low.

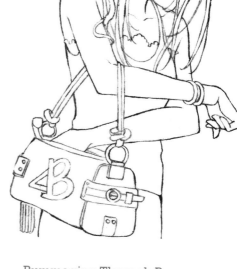

Rummaging Through Purse
It makes it a little more interesting if she digs into her purse. Suddenly, she's actively engaged in doing something, rather than standing still.

Kneeling and Talking
If you can find a secondary action that will reinforce the feeling that a character is interacting with others, then it will be a positive addition to what is otherwise a static scene. You might see this pose if a character is hanging out in a group, maybe at a slumber party or while watching TV.

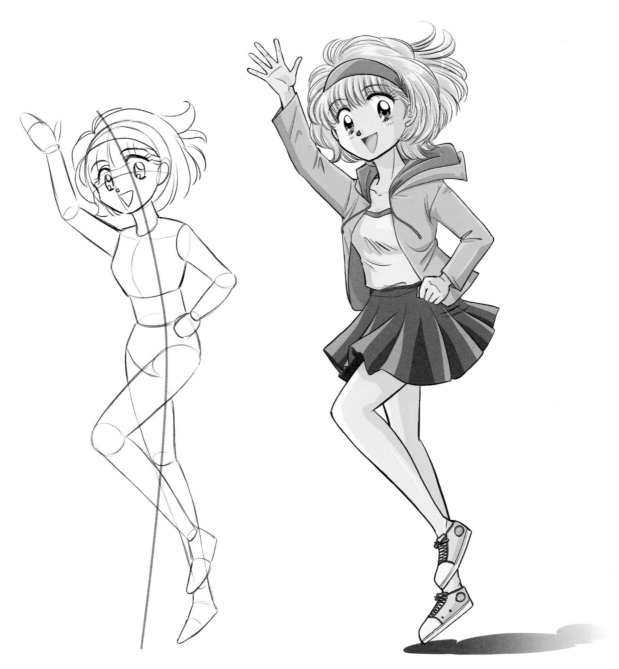

Waving Hello

Her arms and legs are both bent but relaxed as she gives a quick wave to her friend. Note the line of action that curves through her body. This keeps her gesture looking natural. Her skirt and hair move through the air, also conveying a sense of motion.

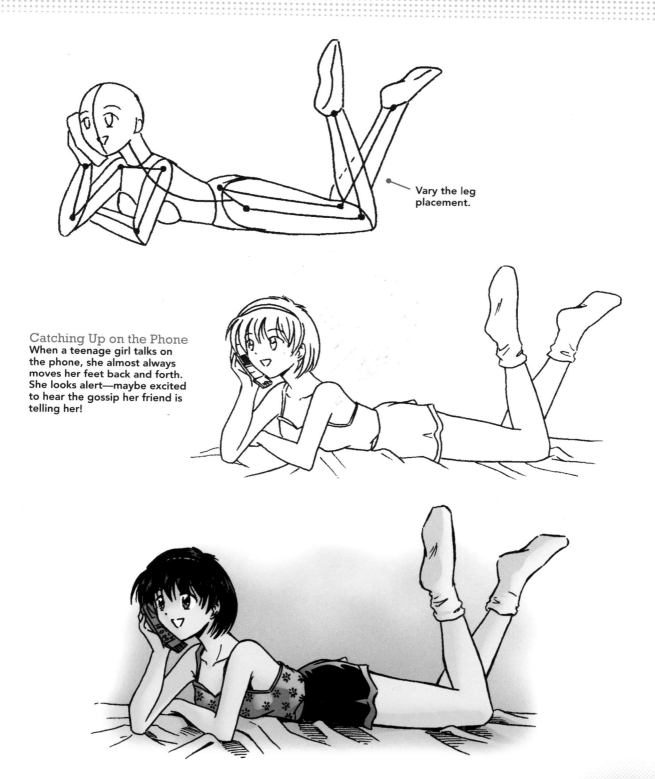

Vary the leg placement.

Catching Up on the Phone

When a teenage girl talks on the phone, she almost always moves her feet back and forth. She looks alert—maybe excited to hear the gossip her friend is telling her!

Expressions

Manga expressions are usually subtle, unless—and this is a big unless—it's a big emotion; then, you can go wild. But otherwise, it's more in keeping with the flavor of the genre to go with breezier, underplayed emotions. Simplicity of expression will help you keep the faces innocent and sweet-looking, rather than distorting them with a lot of facial dynamics. The expressions here can be used to show a character's reaction to something: laughing at their friend's joke, being suspicious of a rival, or seeing their crush walk by!

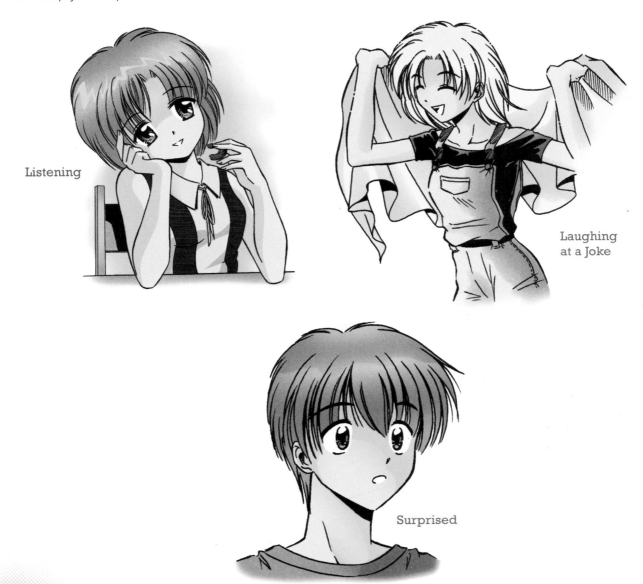

Listening

Laughing at a Joke

Surprised

Worried

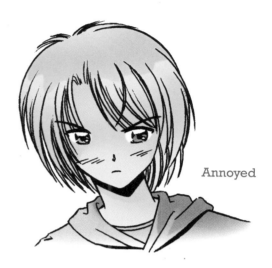

Annoyed

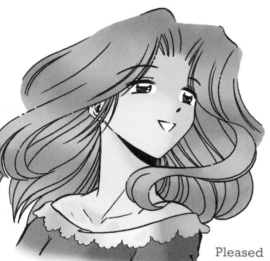

Pleased

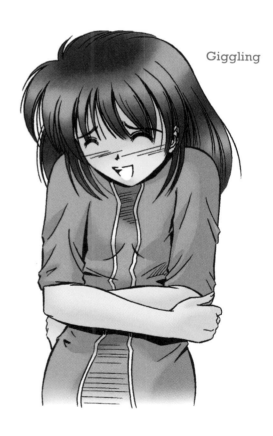

Giggling

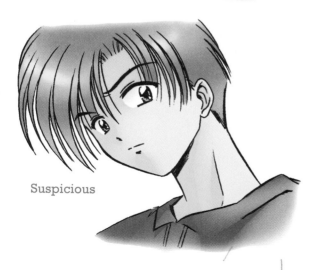

Suspicious

Drawing Groups of Characters

When you're working with multiple characters, it's important to create more than just a unifying visual theme, but *differences*, as well. You don't want them to blend together to such an extent that they lose their individual personalities.

One way to do this is to vary the height of the characters. Varying the heights forces the eye to travel up and down while scanning the image, which makes the eye slow down and take more time to soak in the image. When the characters are all the same height, the eye tends to skim the image quickly, as one whole clump, without looking at each character individually, which is a disadvantage for the artist, who has worked hard to draw each figure.

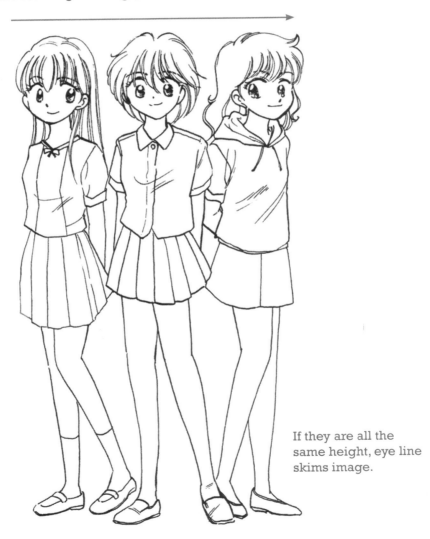

If they are all the same height, eye line skims image.

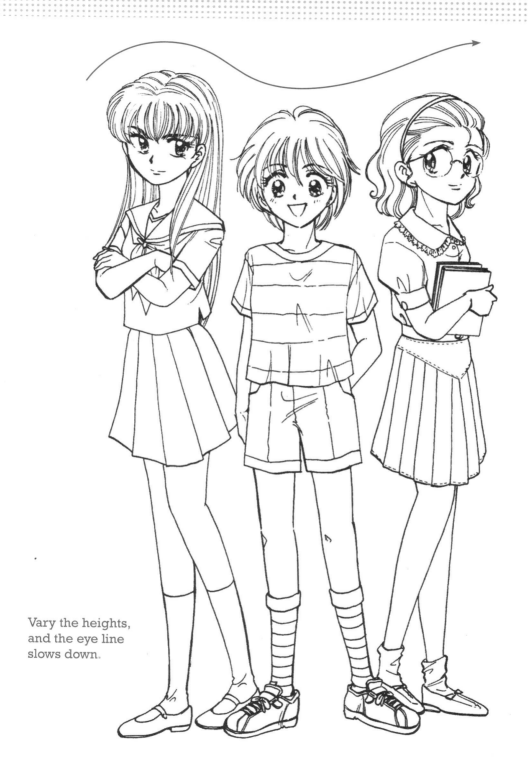

Vary the heights,
and the eye line
slows down.

Comparing Heights

Use this chart as a reference for how tall characters are in comparison with each other. The younger teen boy and girl are almost the same height. But the older teen boy is considerably taller than both of them. Girls always go for the taller, older character over the younger guy. They prefer the mature look to the cute, boyish look. Sorry, shorty!

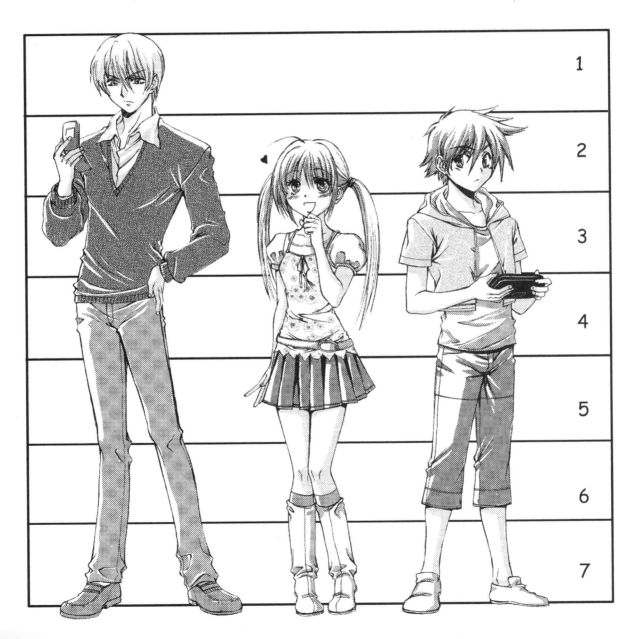

Character Types

School-age characters make up a large portion of manga. They are hugely popular because everyone can relate. Plus, in school, you'll find popular boys, cliquey girls, gossips, outcasts, bullies, authority figures, rebels, and more.

In Japan, where school uniforms are the norm, the school kids have a recognizable look. Their uniforms become de facto costumes, creating a unifying theme among the characters. When drawing groups of school kids, be sure to vary the hairstyles and expressions, so the characters don't look like clones.

Schools are great locations for stories because they offer familiar settings in which people congregate and interact: their lockers, gym class, a bike rack, the cafeteria, etc.

Schoolgirls

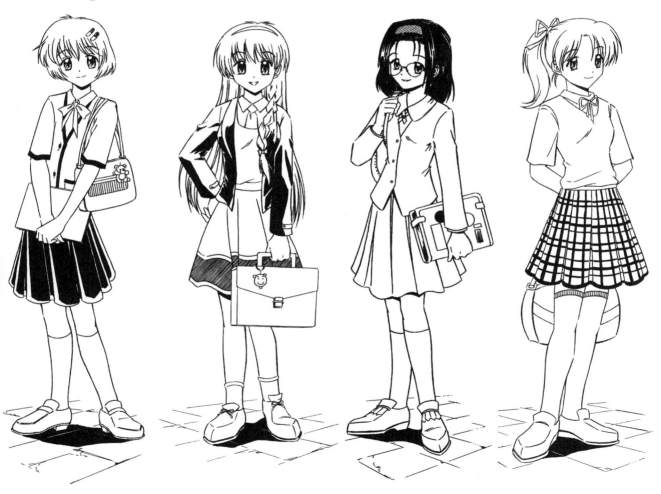

School Friends

Since a lot of manga stories take place in school settings, these character types serve as a starting point for a variety of other character types. Note the authentic Japanese school uniforms.

Athletes

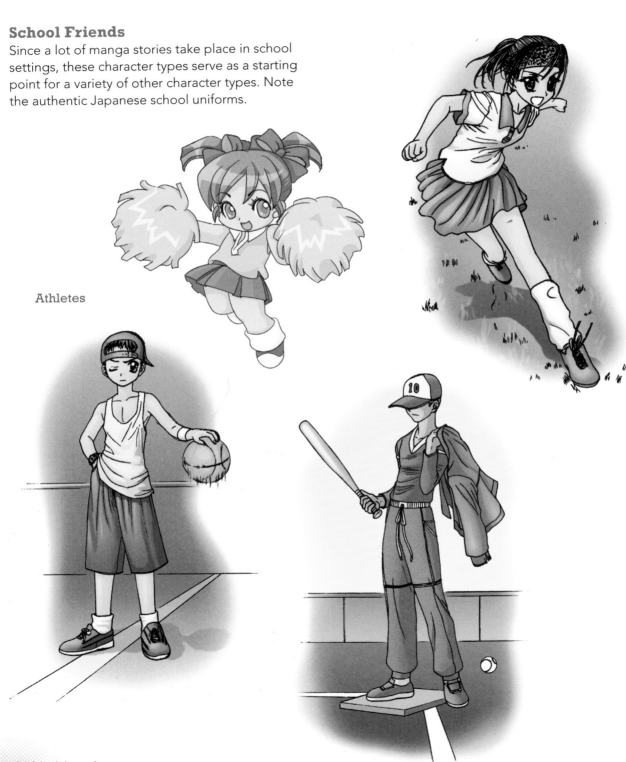

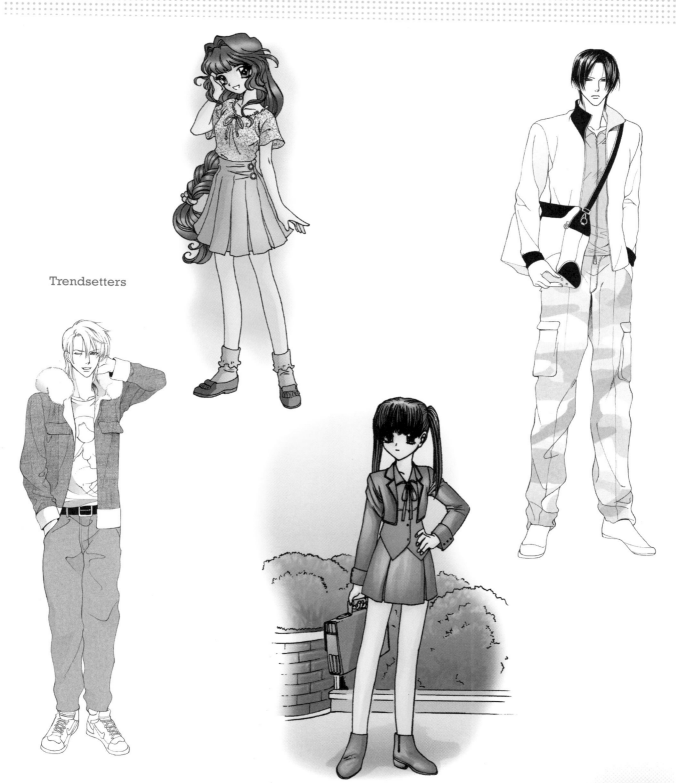

Trendsetters

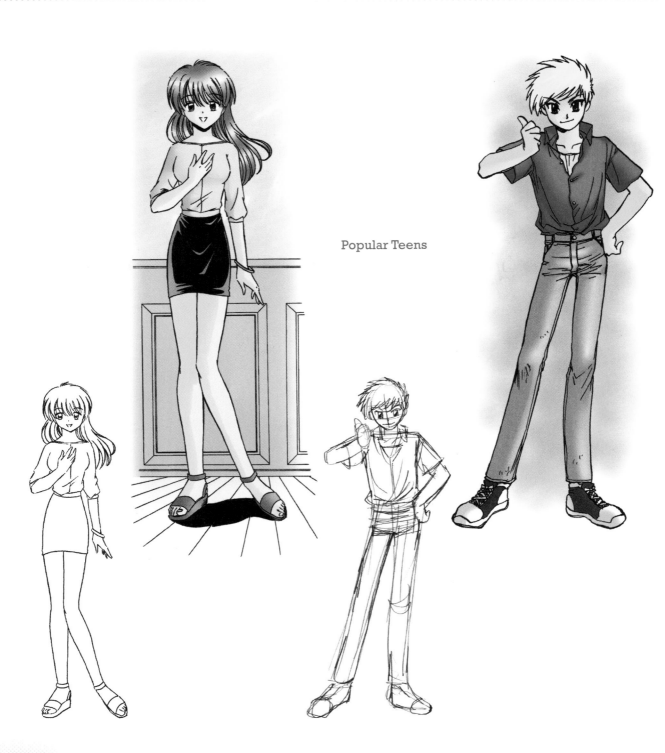

Popular Teens

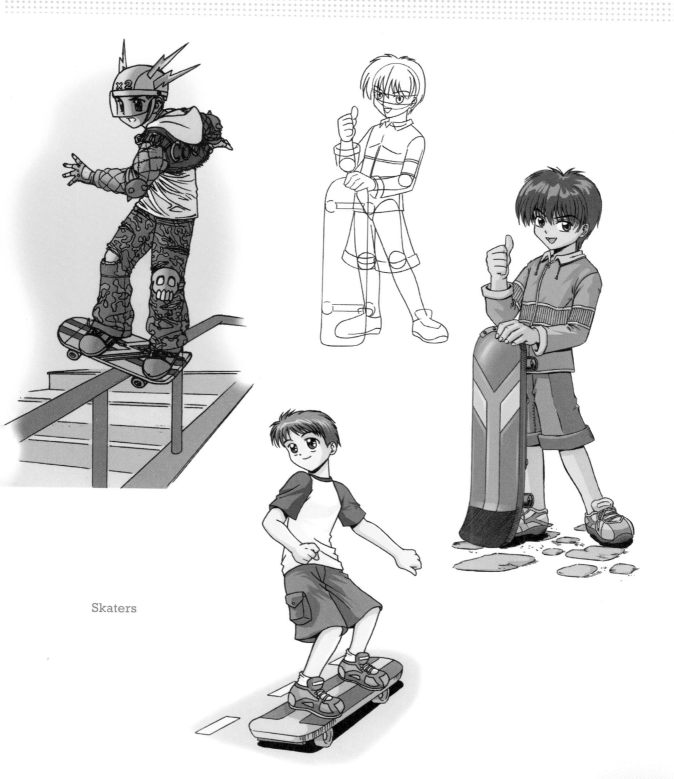

Skaters

Serious Students

Bookish characters are used for humorous relief. They are generally portrayed as a little spacey, oblivious to their surroundings. Only the honk from an oncoming car can wake this kid from his deep thoughts. Studious characters wear glasses, not contacts and never sunglasses. Some studious characters can be a bit evil, turning into mad-scientist types, too!

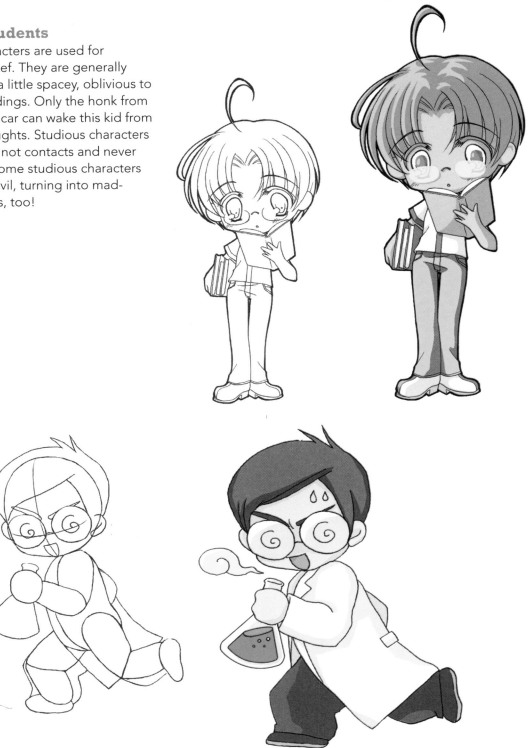

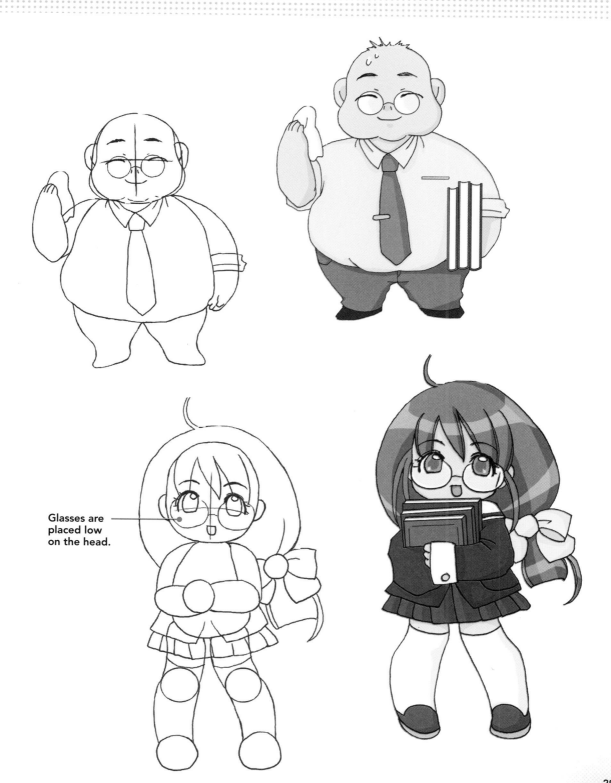

Glasses are placed low on the head.

Magical Girls

Even magical girls stick together, and are often portrayed together as best friends in manga stories. But remember to give each girl her own, individual identity. You give them all *similar* costumes—but with just enough differences to make them look like individuals.

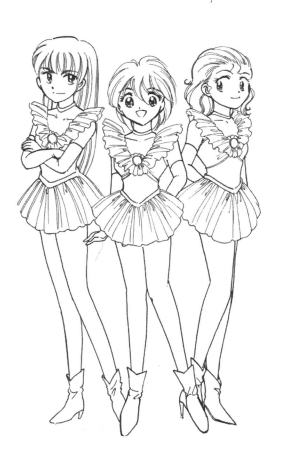

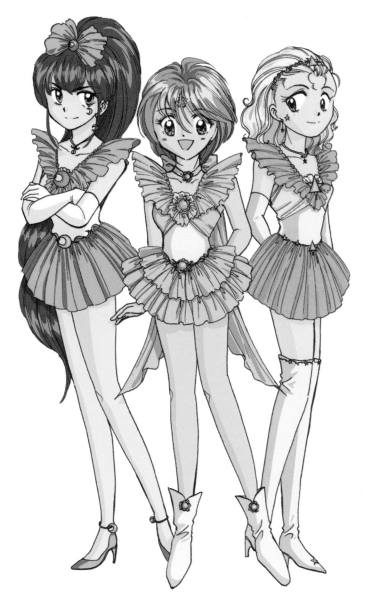

Troublemakers

Put an accent on the eyebrows by making them thick, long, and sharp. This brings out the mischievous quality of these characters.

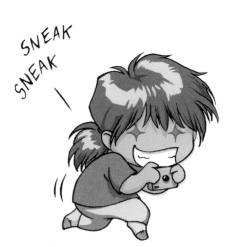

SNEAK
SNEAK

His eyes turn into little starbursts when he's up to no good, and then resume their normal shape when the antics are over.

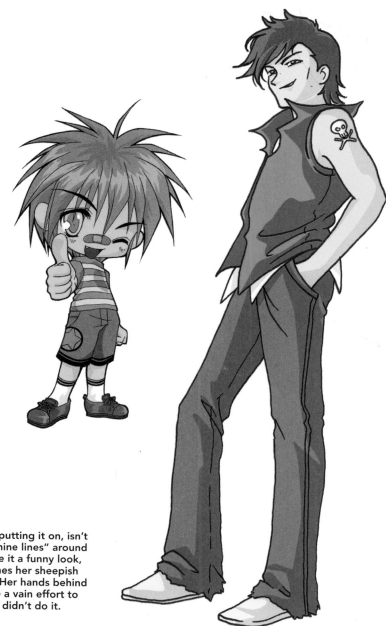

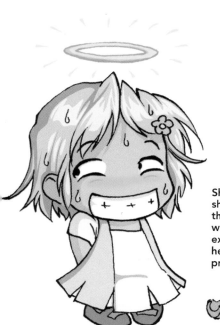

She's really putting it on, isn't she? The "shine lines" around the halo give it a funny look, which matches her sheepish expression. Her hands behind her back are a vain effort to pretend she didn't do it.

Anthro Friends

Anthros show up everywhere in manga, especially in the supercute genre of Kawaii, and are great for creating groups of animal friends. Anthros are humans in animal suits, which have personalities and charm of their own! Group characters wearing similar costumes together in order to convey their friendship.

Deer Girl

Deer Boy

Hamster Girl

Hamster Guy

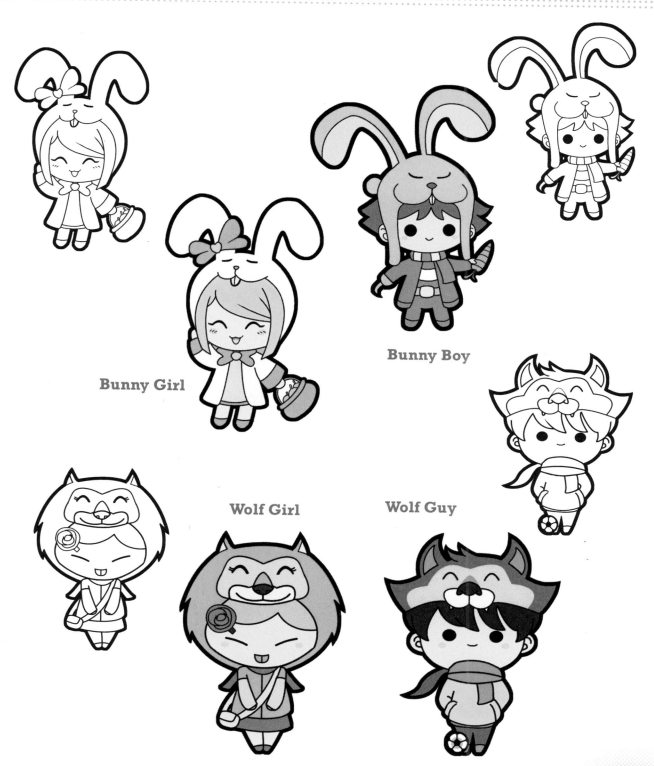

Bunny Girl

Bunny Boy

Wolf Girl

Wolf Guy

Fun Activities Together

As you know, best friends are always looking for fun things to do together. As an artist, you can draw any wild adventure you come up with for your characters. Skydiving together? Not a problem!

Sledding

This is a classic setup, with one character engrossed in the action, while the other character breaks for a moment with a wink to the reader. Manga is the most effective visual art at using this type of reality break. With other styles of cartoons and comics, the result of a "nod" to the reader can be jarring. But with manga, it helps bring the audience into the story and closer to the characters.

Protecting a Friend

The legs are wide apart (for stability) to help him stand his ground. The arms are also wide apart, forming a protective shield. The teeth clench, and the eyes take on a serious expression—with a determined frown.

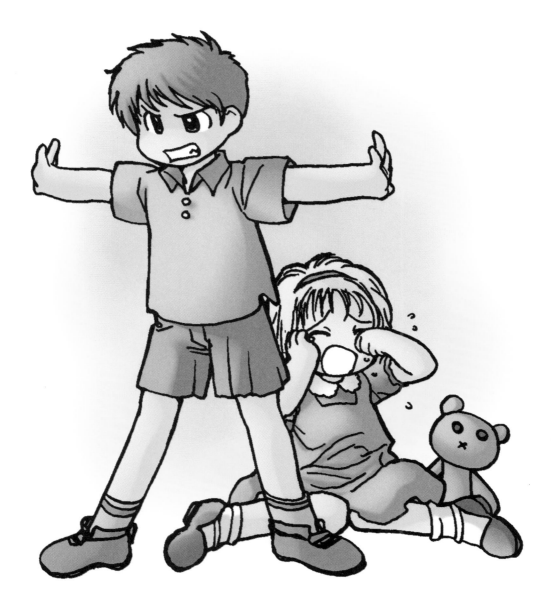

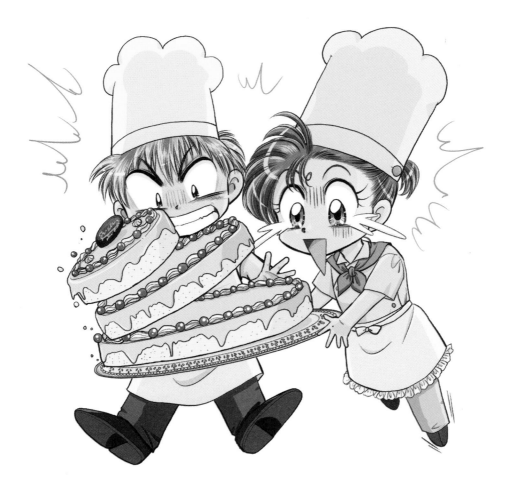

Causing Trouble

The best point at which to illustrate a comedic moment like this one is just as everything is about to go wrong but it's too late to do anything about it. Humor is funniest at the moment of anticipation.

Again, it's the classic comedy setup when two characters are sharing the same moment but having two entirely different emotions—and only the reader is in on the gag! In a scene like this one, it's important that both characters look straight ahead. If they were to look at each other, they would see what the other is thinking, the situation would be revealed, and the moment would be over.

Open her eyes in a surprised look rather than a look of pain. Pain that's made to look silly can be funny, but if something looks like it really hurts, your reader is going to think you're heartless for poking fun at it.

This is a typical moment when characters "chibi-out" (transform from regular manga characters into chibis). The extreme emotion that triggered the event would be a fear of whatever is after them. Notice the gushers streaming from the girl's eyes.

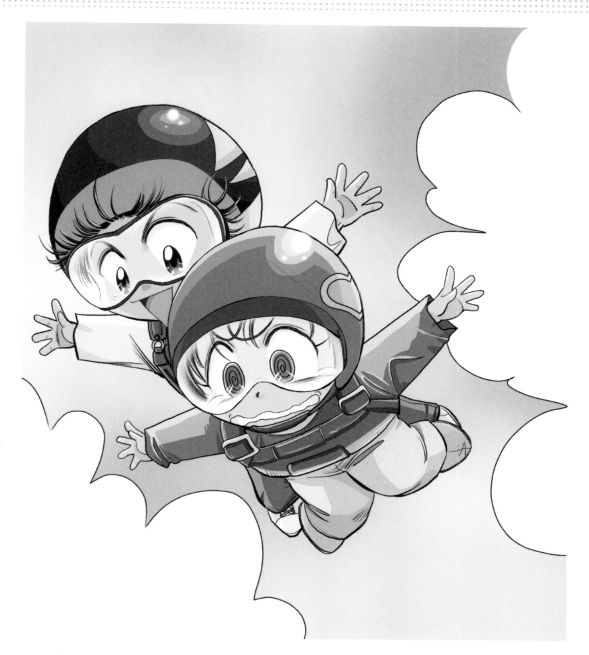

Skydiving

The fun! The thrills! The sheer terror!!!
Here are two people doing the same
thing but having two totally different
experiences—again, that's a perfect setup
for a humorous situation between friends.

PART TWO
Let's Draw It

The Fashionista

Okay, so she's pretty, but does she have to be so obvious about it? And the way she spends her daddy's money on clothes, you'd think she had no other hobbies, except criticizing the mismatched outfits other girls wear. But don't try to stand up to her. She has a razor-sharp tongue, and she's not afraid to use it. She's tight with a few other chic females who make up a closed clique that draws admiring looks from all the boys and major-league resentment from all the other girls.

Torso twists left.

Hips twist right.

1

2

3

Mr. Popular

Give a teenager a red sports car and you've got trouble. This guy is Mr. Popular with his slick set of wheels. As far as drawing is concerned, you can simplify the car if you think of it first as a box. Try to visualize the box as having two sides to it. That'll make it look as if it has dimensions and depth. To keep the proportions correct, take a look at the drawing steps here, which remind you where the boy's figure is in relation to the car. Keep in mind that you should draw him leaning back, with all of his weight against the vehicle. This will give him the cool and casual attitude you want.

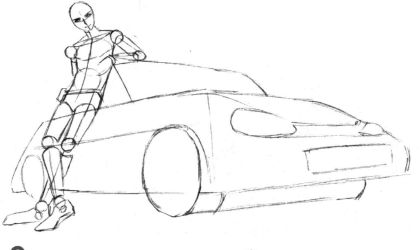

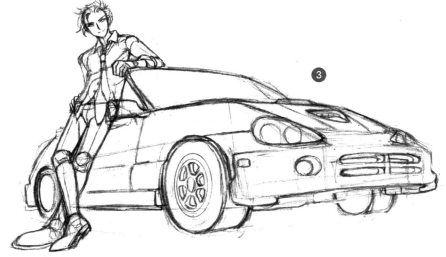

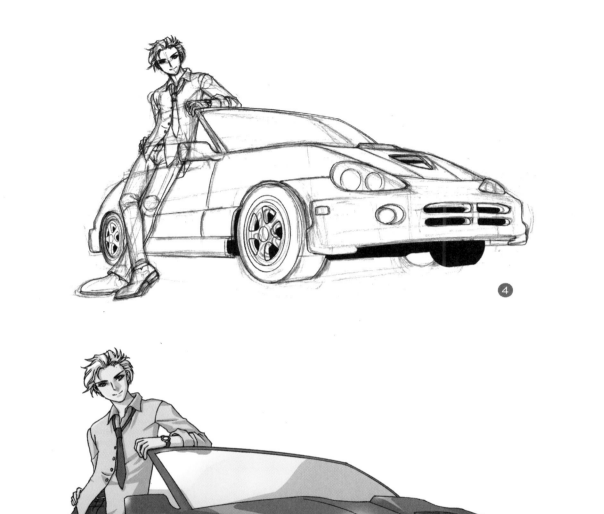

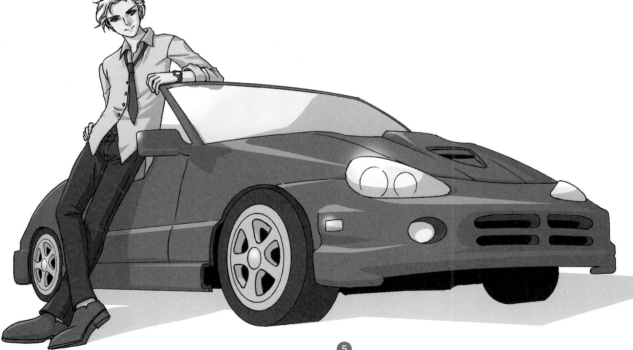

At the Lockers

These girlfriends are gathered around their lockers as one of their crushes walks by. Notice how their faces are at different angles, seen on the different center lines. Even though the girls are all wearing the same uniform, their different hairstyles and colors, and their varying heights, make them each stand out. The boy leans forward with his hands in his pockets, playing it cool.

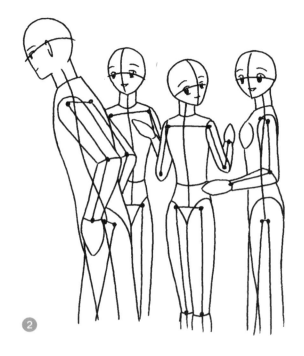

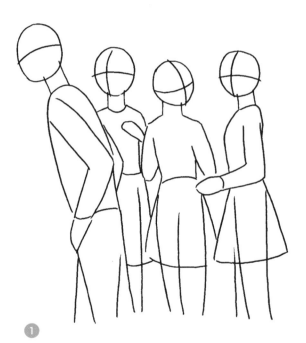

Note the variety in height

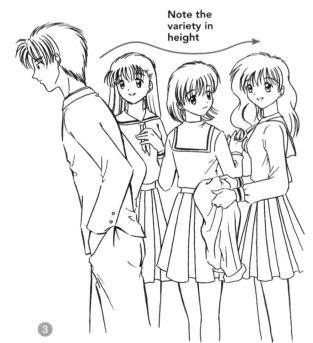

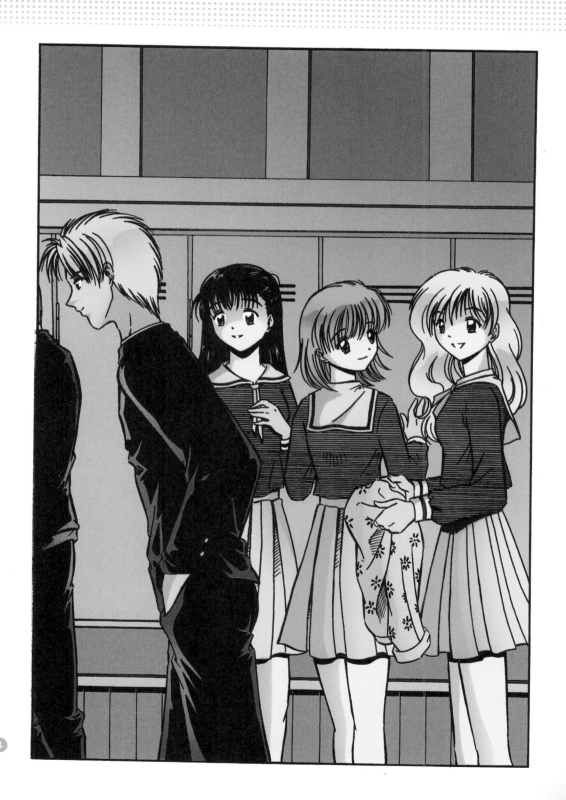

Helping a Friend

Another popular subgenre of manga deals with professions that require uniforms, such as nursing. The character is usually a female who works as a service provider. She's caring and nurturing and befriends her patients. Her pleasant expression and calm pose highlight her friendly relationship with her patient.

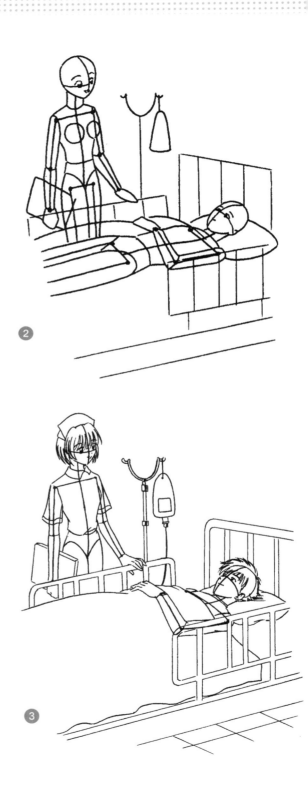

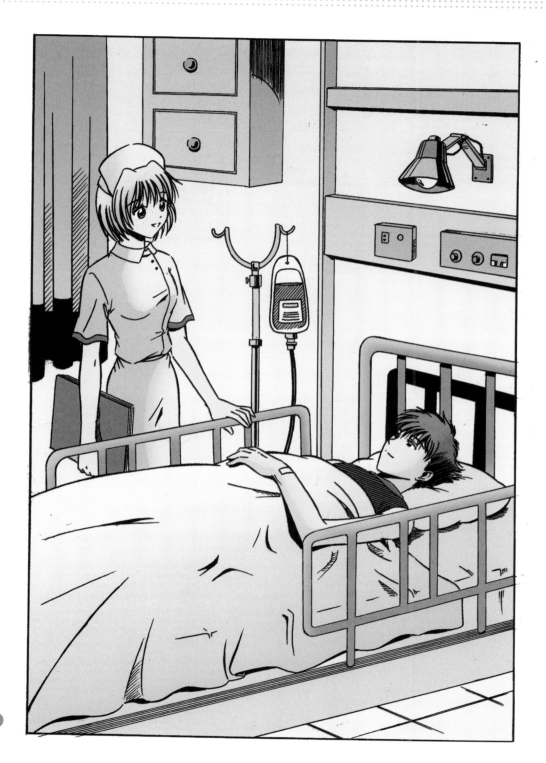

Chatting on the Phone

Here's a picture of two shoujo girls chatting away on their cell phones. What could they be talking about? One girl reclines, while the other lies on her stomach, her feet moving back and forth in the classic "talking on the phone" pose we saw on page 17. Remember, characters don't make eye contact in a split-screen shot!

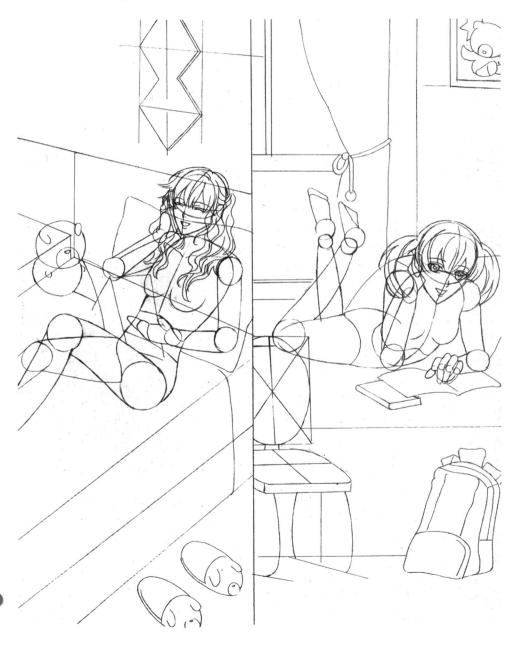

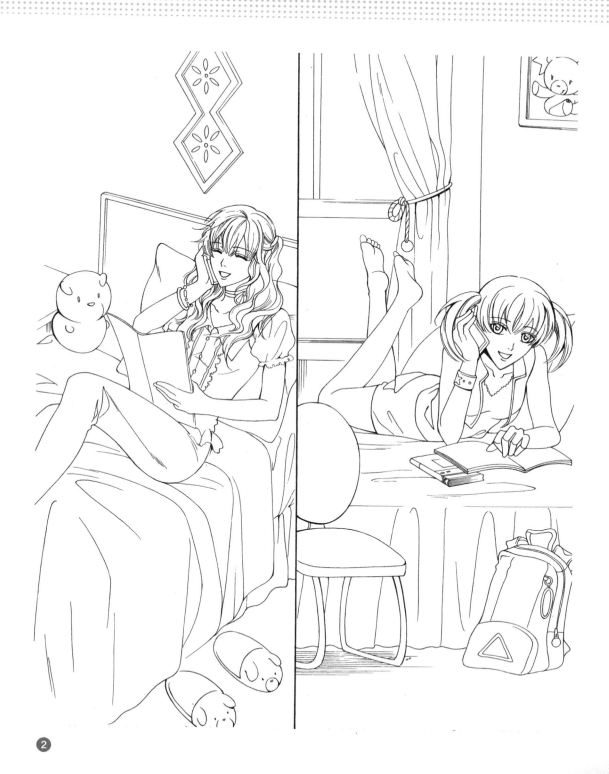

2

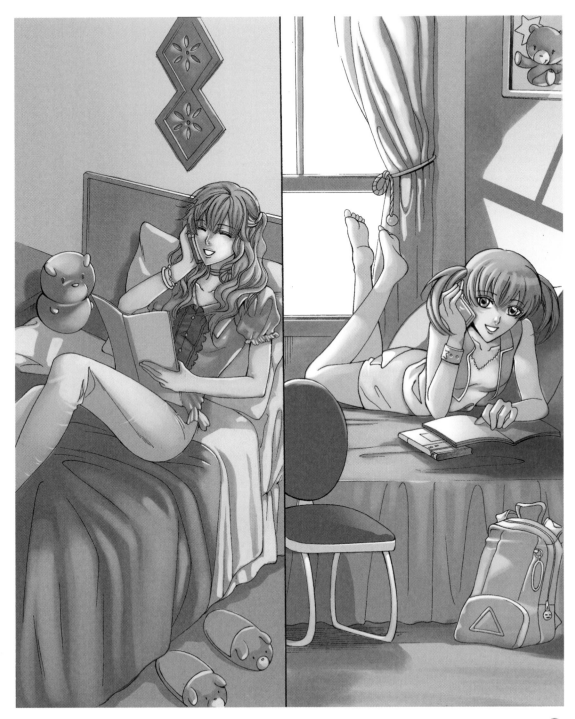

Barbecue

Boys can be food-gobbling pigs! This scene contains small groups of characters laid out in a semicircle, surrounding the campfire. There are groupings of twos, threes, and fours, for variety. Notice that each group is involved in a different action, which adds interest to the scene. One group is hacking from the smoke, the next is cooking over the fire, the next is talking animatedly, and the last (the main couple) is walking and eating. By varying each group's activities, you give your reader a reason to linger on each area, which is what you want as an artist.

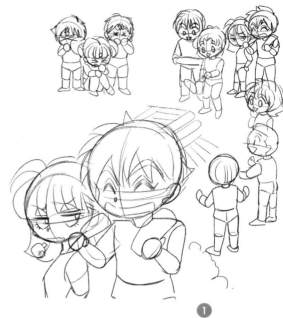

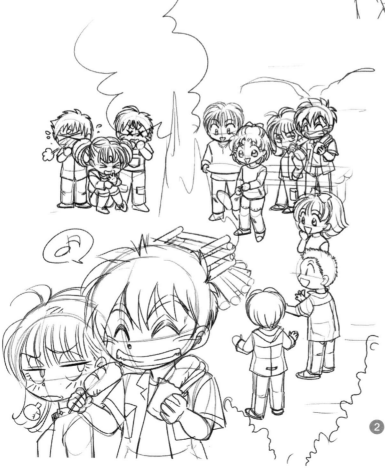

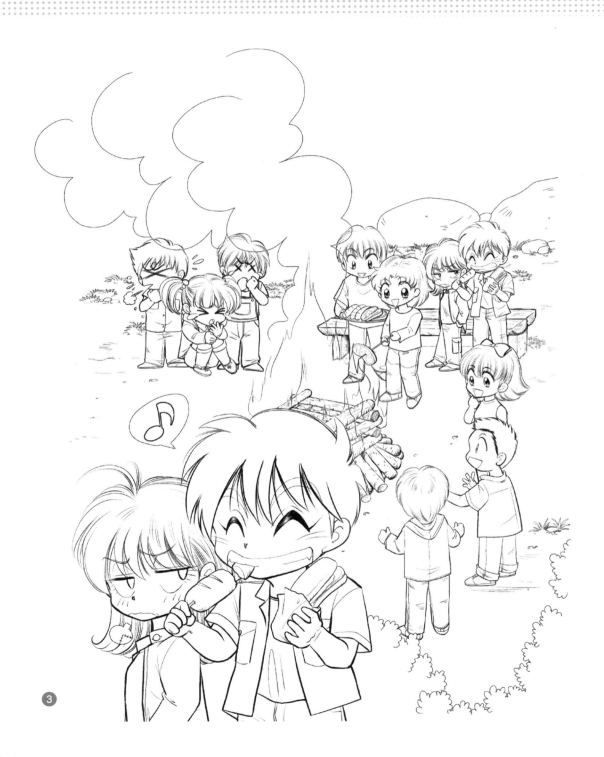

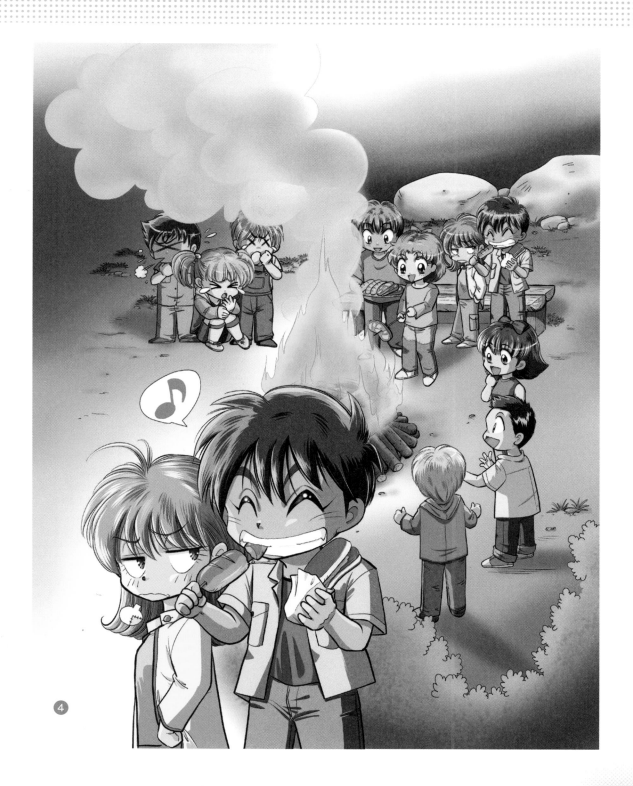

4

Slumber Party

This basic layout has all four girls arranged in a circle so that the eye follows them in a continuous loop, which keeps the reader visually involved. Also, each girl makes eye contact with another girl, which is a method of directing the reader to notice each character rather than focusing on just one.

Vary the sitting and lying positions, as well as the design of the pajamas and types of hairstyles. There isn't much overlapping of the characters, because that would ruin the merry-go-round, circular effect of the layout.

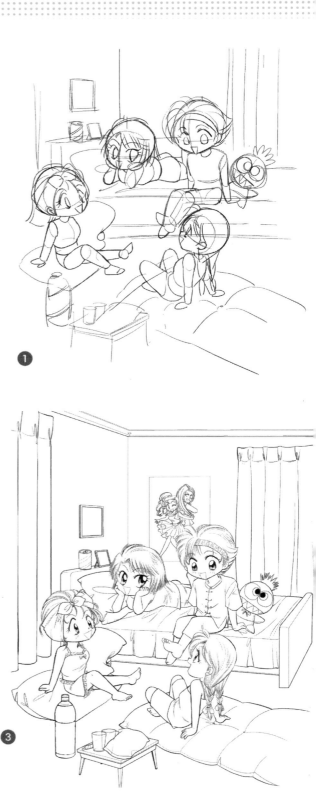

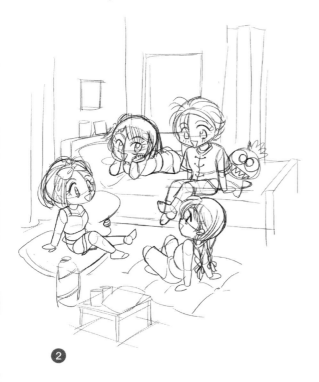

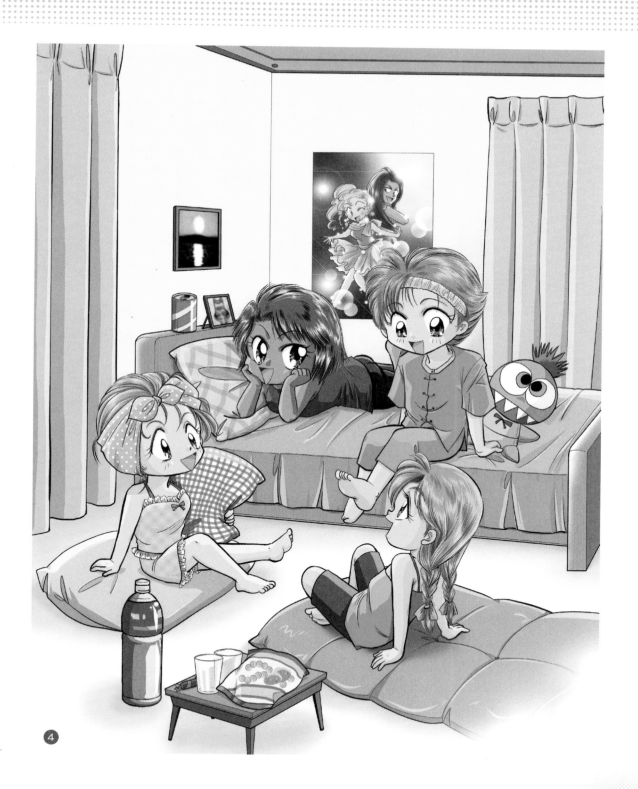

4

Tiger Buddies

This tiger boy is quite spunky. The anthro character is often drawn to reflect the personality traits of the human who wears it, in this case producing an aggressive and bossy tiger. His friend, a girl wearing a similar wild cat costume, is having a rockin' good time as they play catch.

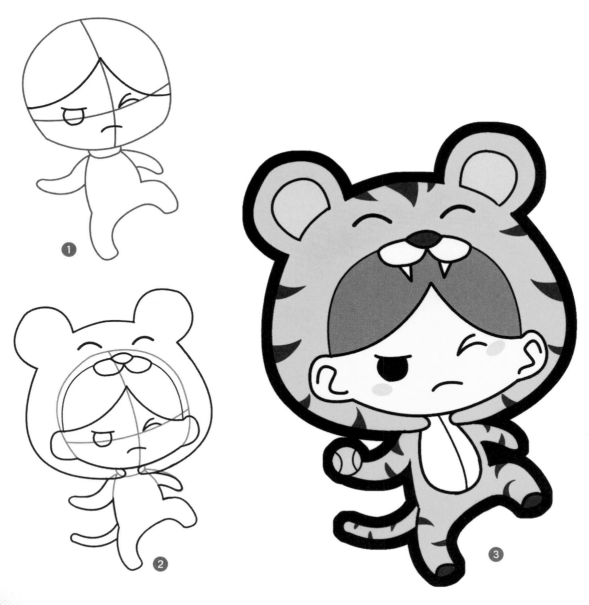

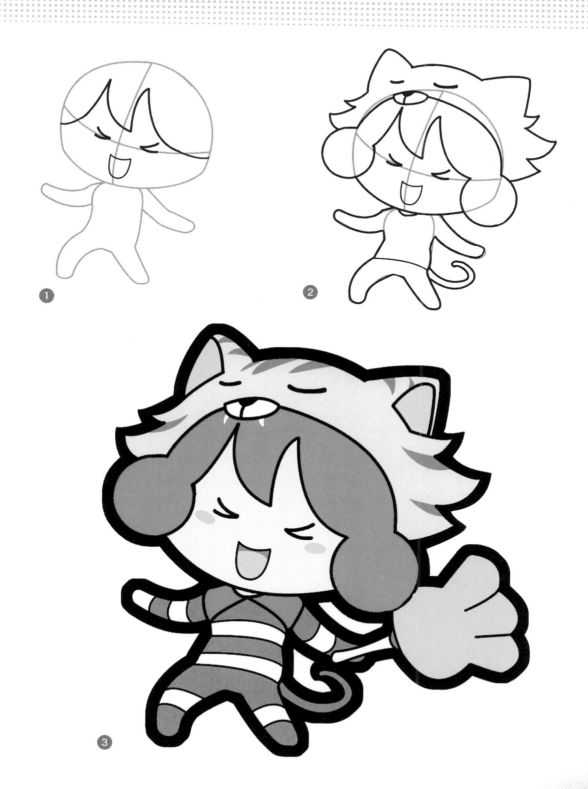

PART THREE
Let's Practice It

Now, let's see just how much you've learned. In this section, you're going to finish the drawings I've already started by adding the face or body or by giving these characters a friend. This is a great way to practice your newly formed skills, and a chance to exercise your own creative license in drawing manga characters. It's been fun—I hope you've had as much fun as I have!

Give this wolf girl a wolf friend.

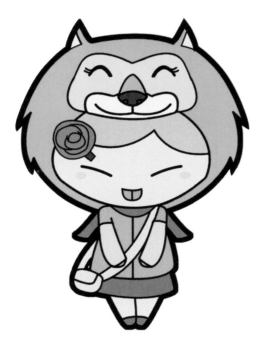

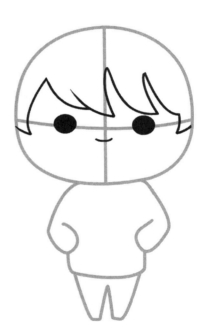

Fill in the features on this studious character's face.

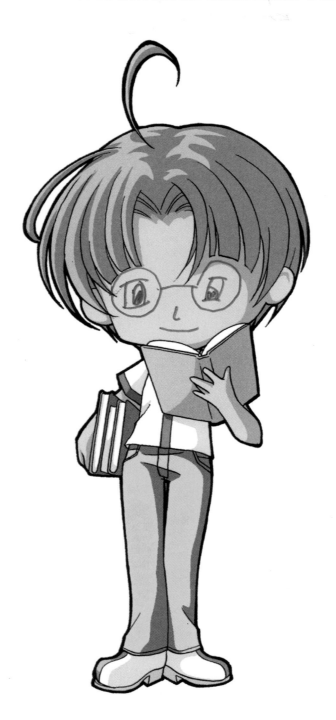

Draw the team rival for this baseball player.

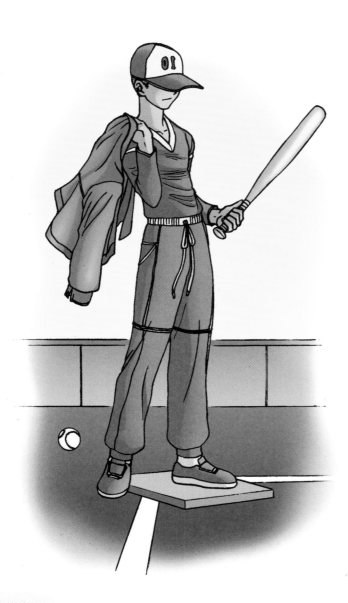

Can you embellish these friends' outfits so
they each have their own individual style?

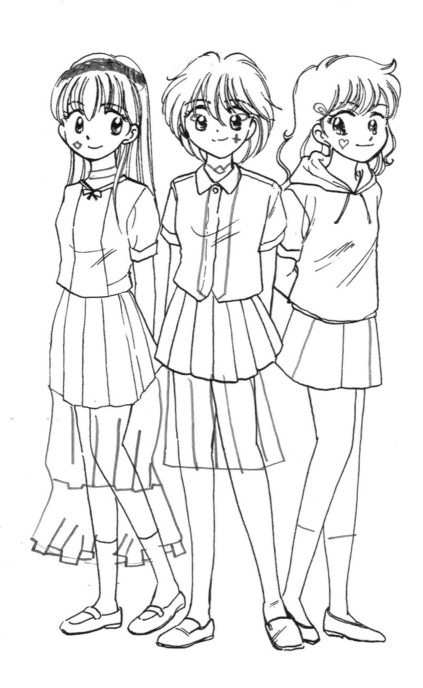

Give this stylish guy a cool pal.

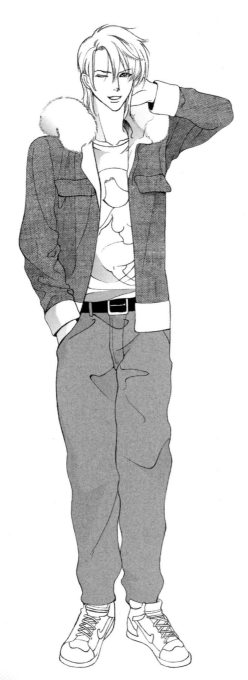

Use these templates to draw manga versions of your own friends.

Also available in *Christopher Hart's Draw Manga Now!* series